7·95

THE KINGDOM
OF HEAVEN IS LIKE

Merula Salaman

Introduction by Alan Bennett

The Herbert Press

Copyright © 1992 Merula Salaman
Copyright under the Berne Convention

First published in Great Britain 1992 by
The Herbert Press Ltd, 46 Northchurch Road, London N1 4EJ

Designed by Pauline Harrison
Typeset in Linotron Kennerley
by Nene Phototypesetters Ltd, Northampton
Printed and bound in Hong Kong
by South China Printing Company (1988) Ltd

Extracts from the Authorised Version of the Bible (The King
James Bible), the rights in which are vested in the Crown,
are reproduced by permission of the Crown's Patentee,
Cambridge University Press.

A CIP catalogue record for this book is
available from the British Library.

ISBN 1–871569–51–6

CONTENTS

INTRODUCTION

────────────

PUT A PET IN A PORTRAIT and the subject becomes a human being. The little dog in Carpaccio's painting of St Augustine in his study makes one think more kindly of the saint himself. Someone who enumerated the sins a baby could commit at the breast can hardly have been relaxing company, but the dog gives one hope. Similarly that cantankerous devil St Jerome can be forgiven much because of the soppy lion that's always lurking about. The animals, one feels, have got it right even if the saints haven't. And so it is with the cat which sits looking on in Merula Salaman's picture of the parable of the lost coin. Under its patient and sceptical eye the kitchen is turned upside down – but when all the losing and finding and rejoicing's done with, this cat is saying, things won't have changed much.

These are secular reflections, though, and the parables are not. There are a score or so in the New Testament, ranging from the very short, thrown off by Jesus in a sentence or two, to fully developed narratives like the parable of the Good Samaritan; and the point of most of them is the same, to instruct his followers in the nature of the Kingdom of Heaven: what it was like, who belonged to it and how.

To Jesus's first hearers the anecdotes and comparisons in which the parables consist were unremarkable; farmers did go out sowing, roads were infested with brigands; shepherds did pasture and lose their sheep on the lonely and inhospitable hillsides of Galilee. So these stories were the stuff of everyday life.

Merula Salaman's paintings catch this ordinariness while at the same time blending the settings of Jesus's time with something of the fairy story. The kitchen where the housewife searches for the lost coin isn't a kitchen in Nazareth, but nor is it a kitchen in Norwich either, and yet it is familiar to us from the books of our childhood. The inn where the Samaritan takes the injured traveller is the kind of inn Mr Toad could have stopped at; Dr Dolittle might book in later. Mind you, the animals in these pictures are far from imaginary; the dogs, for instance (one of whom was called Shem); the Samaritan's donkey lived in the next field to the artist; and the aforesaid cat, looking on so phlegmatically as the kitchen is turned upside down, often sits on Merula Salaman's kitchen table in just the same way.

Parables are not really fairy stories though. In a fairy story the merchant who sold everything (including, I notice, the lampshade) in order to buy his precious pearl would almost certainly end up losing it. But not in the parable. In a fairy story it would be the dutiful son who would finally win his father's heart, whereas in the parable it is the feckless one, the prodigal, who sees the error of his

ways and gains his father's love. 'But how long can the young man keep it up?' you are left asking. 'Has he really turned over a new leaf? And will the father forgive him again? And again? And what will the brother feel then?' And this of course is one of the virtues of the form: parables make one ask questions.

Still, they are sometimes quite hard to take. One finds oneself sympathizing with the wrong person, coming down on the other side of the fence, liking the dutiful son, for instance, but disliking the wise virgins. These were the bridesmaids who had their lamps all topped up against the arrival of the wedding procession; and not only that, they had oil to spare as well. Picture the scene. Along comes the bridegroom and his party, all poshed up and ready for the ceremony, when all hell breaks loose among the waiting bridesmaids. The sillier girls, who have been busy powdering their noses, now find they don't have a match between them and that they're fresh out of oil. Their smugger sisters have meanwhile bustled forward, lamps lit, oil at the ready, and are already following the groom's party in for a slap-up do. 'Lend us a drop of your oil,' say the dozy ones. 'No fear!' say the self-satisfied sisters, 'Serve you right.' Well, I know which side I'm on.

Besides, where would the Prodigal Son be in similar circumstances? No oil in his lamp, one can be sure; and talking of weddings, the dutiful son (on the wrong side of one parable) would seem an ideal partner for one of the wise virgins (on the right side

in another) – though she might not fancy having a brother-in-law who's been caught eating the pig food.

These reflections aren't as flippant as they seem, because they serve to reveal what the parables are not. They are not homilies. We are not being asked to admire character or being given lessons in morality. Character and morality count for nothing beside forgiveness and redemption. Divine forgiveness and redemption is the new order of things, and the new order of things was the Kingdom of Heaven. This is what Jesus was preaching and this is what most of the parables are about. But the knot has to be untied and in the untying Jesus's listeners (and Jesus's readers) learn, as one still may, what he meant when he said, 'The Kingdom of Heaven is like ...'

ALAN BENNETT

THE SOWER AND THE SEED

Jesus spoke to the people about the Kingdom of God, and the people flocked in their multitudes to hear him, and he taught them in parables. About God's word, he said:

A SOWER WENT OUT to sow his seed: and as he sowed, some fell by the way side; and it was trodden down, and the fowls of the air devoured it. And some fell upon a rock; and as soon as it was sprung up, it withered away, because it lacked moisture. And some fell among thorns; and the thorns sprang up with it, and choked it. And other fell on good ground, and sprang up, and bare fruit an hundredfold. And when he had said these things, he cried, He that hath ears to hear, let him hear.

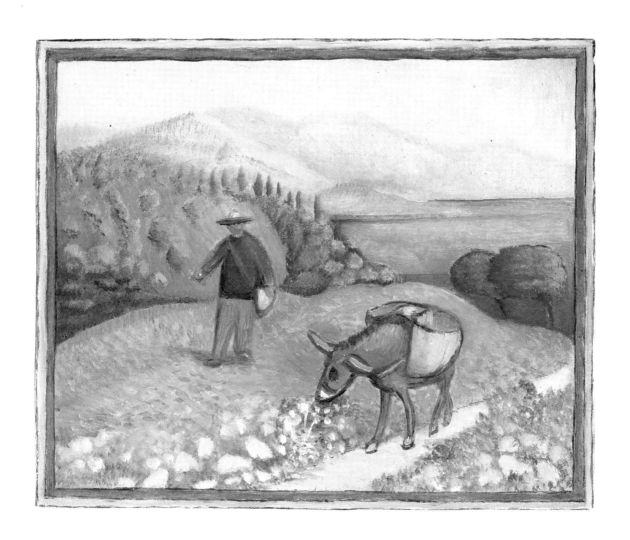

THE MUSTARD SEED

WHEREUNTO SHALL WE LIKEN the kingdom of God? or with what comparison shall we compare it? It is like a grain of mustard seed, which, when it is sown in the earth, is less than all the seeds that be in the earth: but when it is sown, it groweth up, and becometh greater than all herbs, and shooteth out great branches; so that the fowls of the air may lodge under the shadow of it.

THE HIDDEN TREASURE

AGAIN, THE KINGDOM OF HEAVEN is like unto treasure hid in a field; the which when a man hath found, he hideth, and for joy thereof goeth and selleth all that he hath, and buyeth that field.

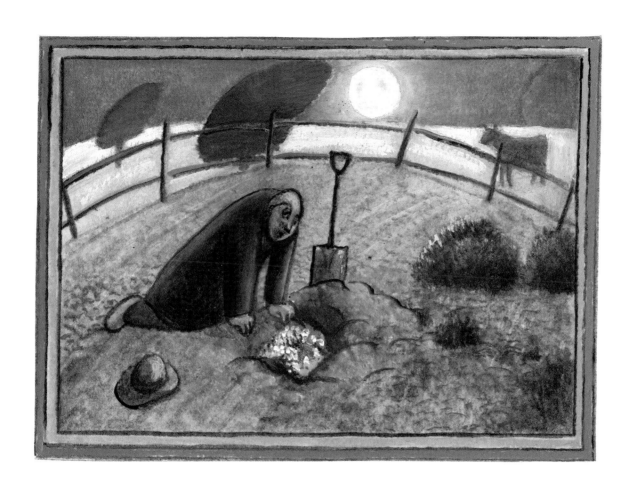

THE PEARL OF GREAT PRICE

AGAIN, THE KINGDOM OF HEAVEN is like unto a merchant man, seeking goodly pearls: who, when he had found one pearl of great price, went and sold all that he had, and bought it.

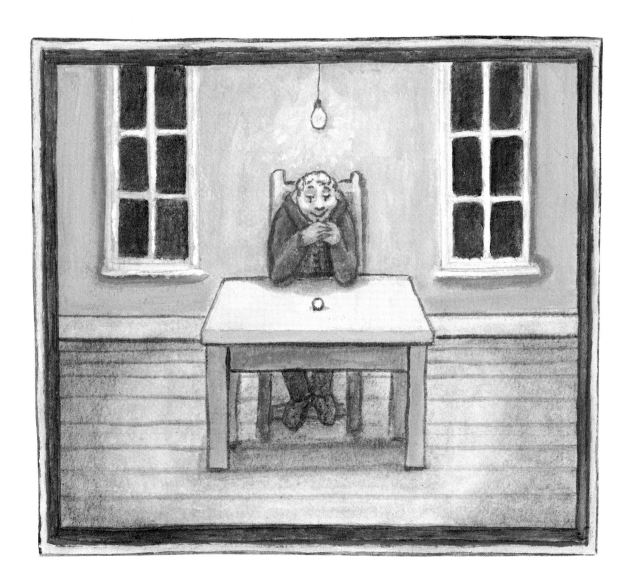

THE LOST SHEEP

The Pharisees complained to Jesus that he ate and drank with the outcasts of society, prostitutes and tax gatherers, and Jesus replied:

WHAT MAN OF YOU, having an hundred sheep, if he lose one of them, doth not leave the ninety and nine in the wilderness, and go after that which is lost, until he find it?

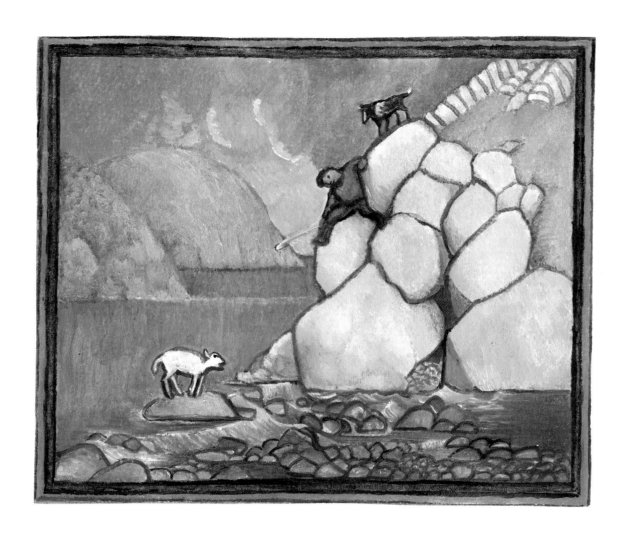

And when he hath found it, he layeth it on his shoulders, rejoicing. And when he cometh home, he calleth together his friends and neighbours, saying unto them, Rejoice with me; for I have found my sheep which was lost. I say unto you, that likewise joy shall be in heaven over one sinner that repenteth, more than over ninety and nine just persons, which need no repentance.

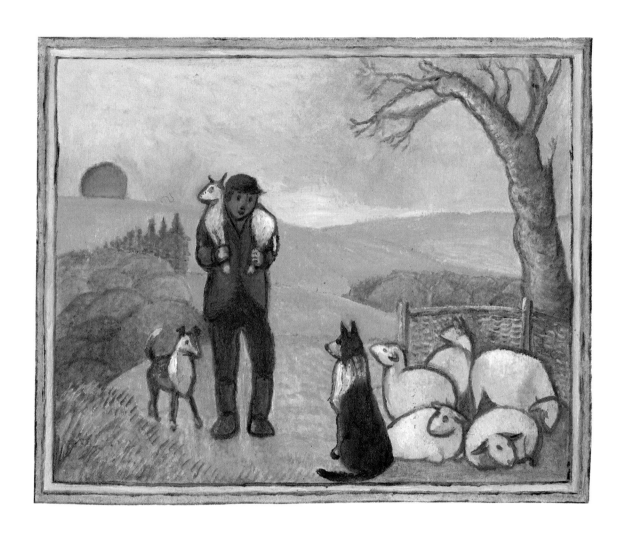

THE LOST COIN

EITHER WHAT WOMAN having ten pieces of silver, if she lose one piece, doth not light a candle, and sweep the house, and seek diligently till she find it? And when she hath found it, she calleth her friends and her neighbours together, saying, Rejoice with me; for I have found the piece which I had lost. Likewise, I say unto you, there is joy in the presence of the angels of God over one sinner that repenteth.

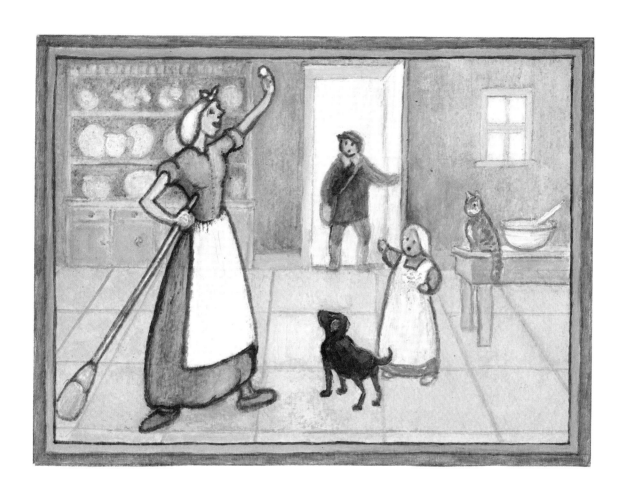

THE PRODIGAL SON

A CERTAIN MAN had two sons: and the younger of them said to his father, Father, give me the portion of goods that falleth to me. And he divided unto them his living. And not many days after the younger son gathered all together, and took his journey into a far country, and there wasted his substance with riotous living.

And when he had spent all, there arose a mighty famine in that land; and he began to be in want. And he went and joined himself to a citizen of that country; and he sent him into his fields to feed swine.

And he would fain have filled his belly with the husks that the swine did eat: and no man gave unto him. And when he came to himself, he said, How many hired servants of my father's have bread enough and to spare, and I perish with hunger! I will arise and go to my father, and will say unto him, Father, I have sinned against heaven, and before thee, and am no more worthy to be called thy son: make me as one of thy hired servants.

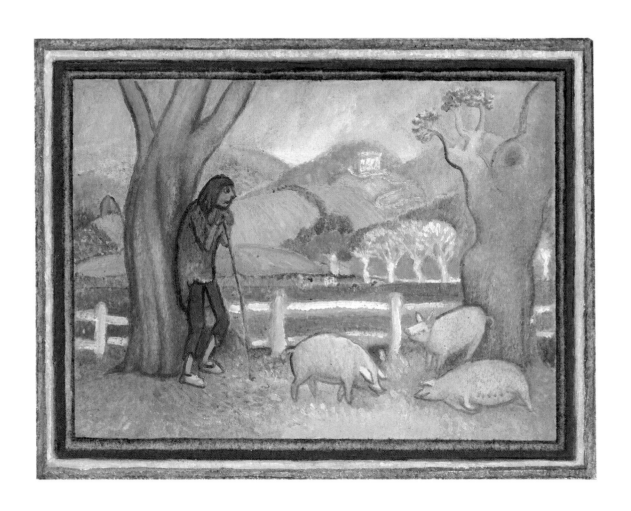

And he arose, and came to his father.

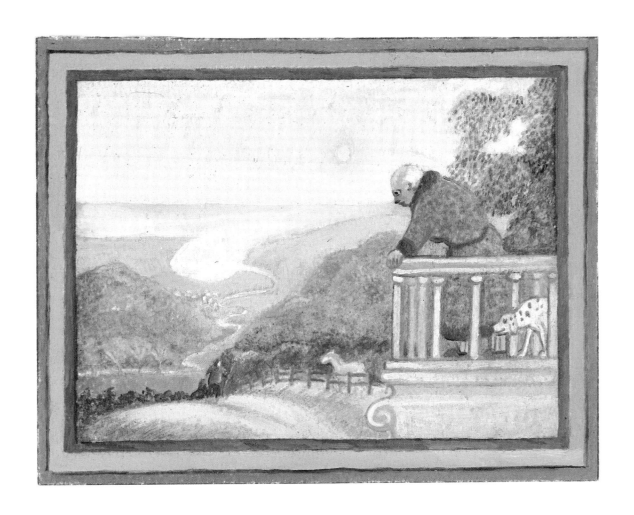

But when he was yet a great way off, his father saw him, and had compassion, and ran, and fell on his neck, and kissed him. And the son said unto him, Father, I have sinned against heaven, and in thy sight, and am no more worthy to be called thy son. But the father said to his servants, Bring forth the best robe, and put it on him; and put a ring on his hand, and shoes on his feet: and bring hither the fatted calf, and kill it; and let us eat, and be merry: for this my son was dead, and is alive again; he was lost, and is found.

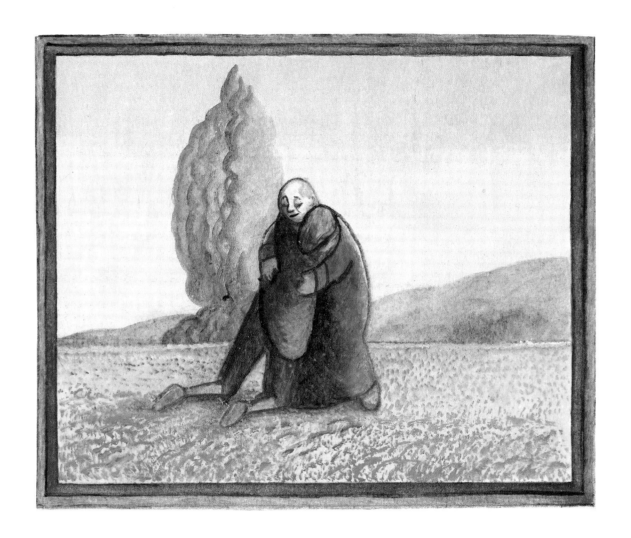

And they began to be merry. Now his elder son was in the field: and as he came and drew nigh to the house, he heard musick and dancing. And he called one of the servants, and asked what these things meant. And he said unto him, Thy brother is come; and thy father hath killed the fatted calf, because he hath received him safe and sound. And he was angry, and would not go in: therefore came his father out, and intreated him. And he answering said to his father, Lo, these many years do I serve thee, neither transgressed I at any time thy commandment: and yet thou never gavest me a kid, that I might make merry with my friends: But as soon as this thy son was come, which hath devoured thy living with harlots, thou hast killed for him the fatted calf. And he said unto him, Son, thou art ever with me, and all that I have is thine. It was meet that we should make merry, and be glad: for this thy brother was dead, and is alive again; and was lost, and is found.

———————

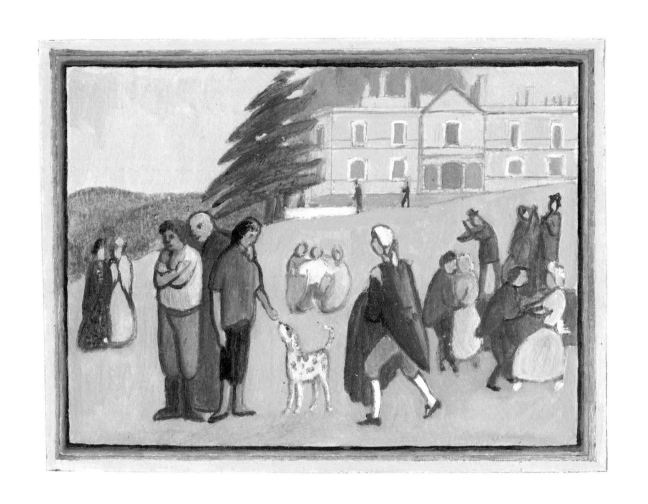

THE UNFORGIVING SERVANT

Peter said to Jesus: 'How many times must I forgive my brother who sins against me? Seven times?' Jesus said, 'Not seven times, but seventy times seven.' And he told this parable:

THEREFORE IS THE KINGDOM OF HEAVEN likened unto a certain king, which would take account of his servants. And when he had begun to reckon, one was brought unto him, which owed him ten thousand talents. But forasmuch as he had not to pay, his lord commanded him to be sold, and his wife, and children, and all that he had, and payment to be made. The servant therefore fell down, and worshipped him, saying, Lord, have patience with me, and I will pay thee all. Then the lord of that servant was moved with compassion, and loosed him, and forgave him the debt.

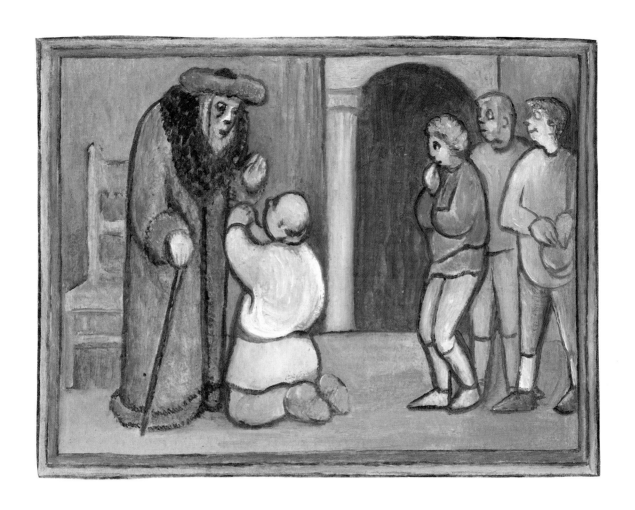

But the same servant went out, and found one of his fellowservants, which owed him an hundred pence: and he laid hands on him, and took him by the throat, saying, Pay me that thou owest. And his fellowservant fell down at his feet, and besought him, saying, Have patience with me, and I will pay thee all. And he would not: but went and cast him into prison, till he should pay the debt. So when his fellowservants saw what was done, they were very sorry, and came and told unto their lord all that was done. Then his lord, after that he had called him, said unto him, O thou wicked servant, I forgave thee all that debt, because thou desiredst me: shouldest not thou also have had compassion on thy fellowservant, even as I had pity on thee? And his lord was wroth, and delivered him to the tormentors, till he should pay all that was due unto him. So likewise shall my heavenly Father do also unto you, if ye from your hearts forgive not every one his brother their trespasses.

———————————

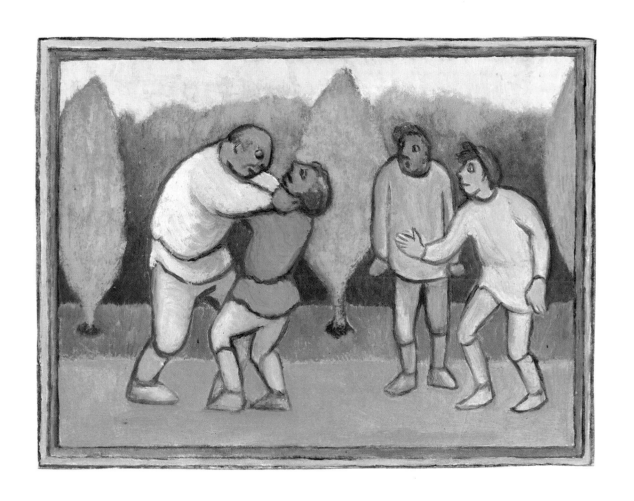

THE BARREN FIG TREE

A CERTAIN MAN had a fig tree planted in his vineyard; and he came and sought fruit thereon, and found none. Then said he unto the dresser of his vineyard, Behold, these three years I come seeking fruit on this fig tree, and find none: cut it down; why cumbereth it the ground? And he answering said unto him, Lord, let it alone this year also, till I shall dig about it, and dung it: And if it bear fruit, well: and if not, then after that thou shalt cut it down.

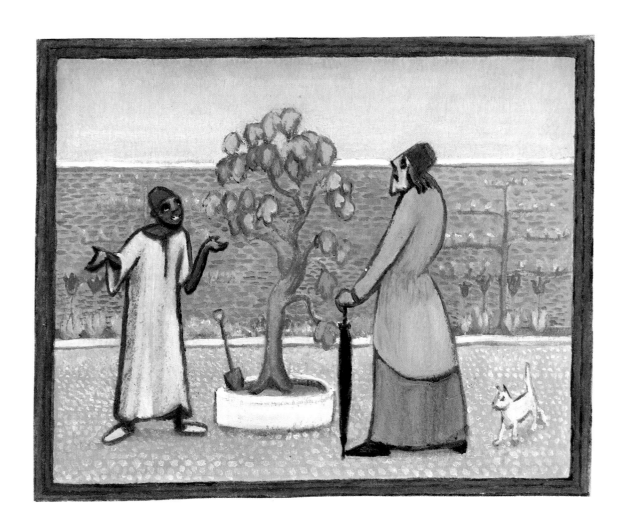

THE GOOD SAMARITAN

A lawyer stood up and asked Jesus, testing him, 'What shall I do to gain eternal life?' Jesus answered 'What is written in the law?', and the lawyer replied 'You shall love the Lord your God with all your heart and all your mind, and your neighbour as yourself.' Jesus said, 'That is correct; do this and you will have eternal life.' But the lawyer asked, 'Who is my neighbour?' Jesus said:

A CERTAIN MAN went down from Jerusalem to Jericho, and fell among thieves, which stripped him of his raiment, and wounded him, and departed, leaving him half dead.

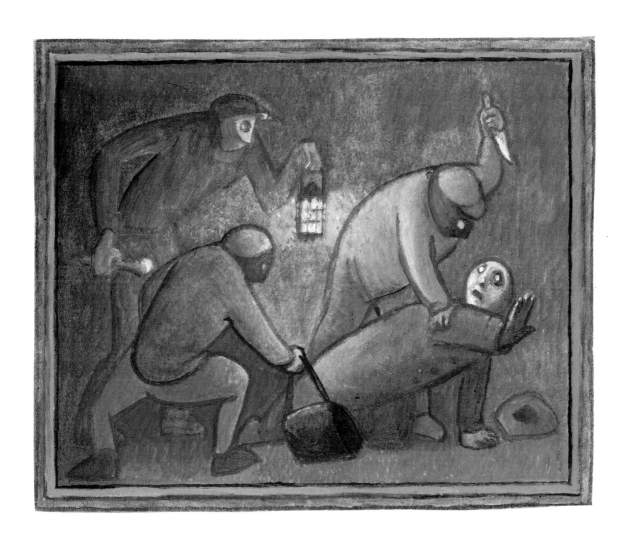

And by chance there came down a certain priest that way: and when he saw him, he passed by on the other side. And likewise a Levite, when he was at the place, came and looked on him, and passed by on the other side.

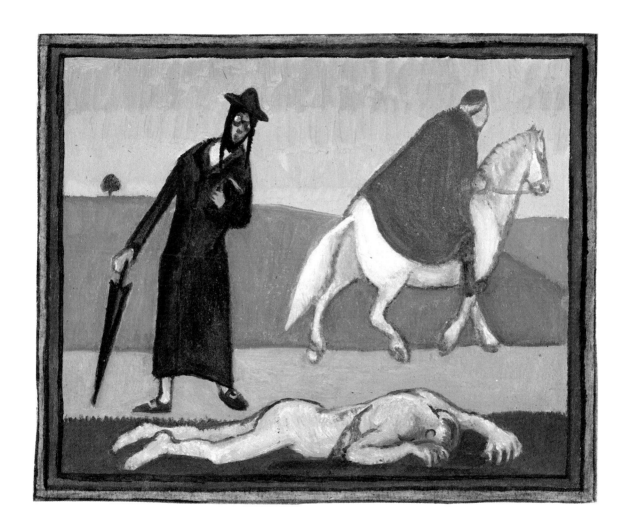

But a certain Samaritan, as he journeyed, came where he was: and when he saw him, he had compassion on him, and went to him, and bound up his wounds, pouring in oil and wine, and set him on his own beast, and brought him to an inn, and took care of him.

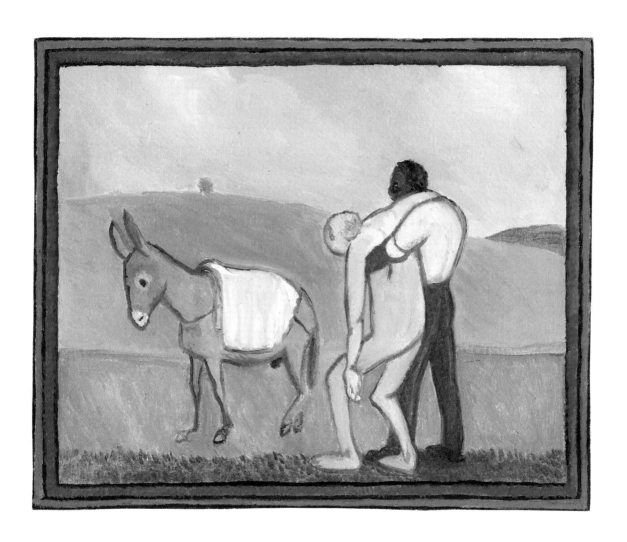

And on the morrow when he departed, he took out two pence, and gave them to the host, and said unto him, Take care of him; and whatsoever thou spendest more, when I come again, I will repay thee. Which now of these three, thinkest thou, was neighbour unto him that fell among the thieves? And he said, He that shewed mercy on him. Then said Jesus unto him, Go, and do thou likewise.

———————

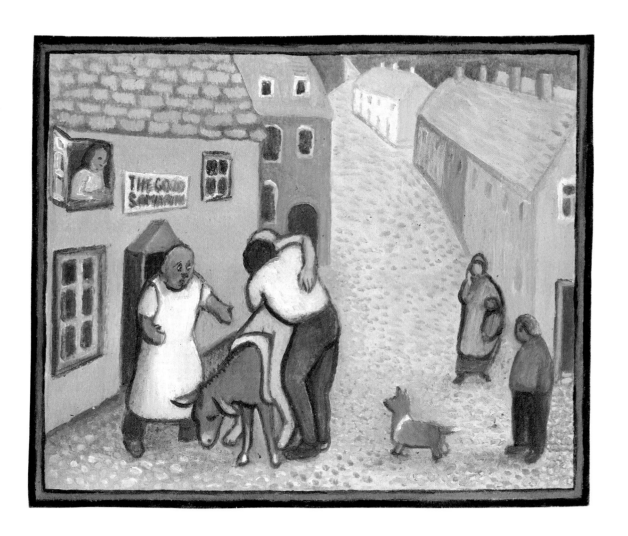

THE WORKERS IN THE VINEYARD

FOR THE KINGDOM OF HEAVEN is like unto a man that is an householder, which went out early in the morning to hire labourers into his vineyard. And when he had agreed with the labourers for a penny a day, he sent them into his vineyard. And he went out about the third hour, and saw others standing idle in the marketplace, and said unto them; Go ye also into the vineyard, and whatsoever is right I will give you. And they went their way. Again he went out about the sixth and ninth hour, and did likewise. And about the eleventh hour he went out, and found others standing idle, and saith unto them, Why stand ye here all the day idle? They say unto him, Because no man hath hired us. He saith unto them, Go ye also into the vineyard; and whatsoever is right, that shall ye receive.

So when even was come, the lord of the vineyard saith unto his steward, Call the labourers, and give them their hire, beginning from the last unto the first. And when they came that were hired about the eleventh hour, they received every man a penny. But when the first came, they supposed that they should have received more; and they likewise received every man a penny. And when they had received it, they murmured against the goodman of the house, saying, These last have wrought but one hour, and thou hast made them equal unto us, which have borne the burden and heat of the day. But he answered one of them, and said, Friend, I do thee no wrong: didst not thou agree with me for a penny? Take that thine is, and go thy way: I will give unto this last, even as unto thee. Is it not lawful for me to do what I will with mine own? Is thine eye evil, because I am good? So the last shall be first, and the first last: for many be called, but few chosen.

———————

THE TEN VIRGINS

The disciples asked, 'When will the world end, and what sign will there be?' And Jesus answered: 'There will be no sign given. Be prepared always, and pray, for if the householder knew the thieves would break in, his house would not have been burgled. A lazy servant says to himself "My master is long in coming," and gets drunk, and beats his fellow servants, and then his master comes when he least expects him.'

THEN SHALL THE KINGDOM OF HEAVEN be likened unto ten virgins, which took their lamps, and went forth to meet the bridegroom. And five of them were wise, and five were foolish. They that were foolish took their lamps, and took no oil with them: But the wise took oil in their vessels with their lamps. While the bridegroom tarried, they all slumbered and slept. And at midnight there was a cry made, Behold, the bridegroom cometh; go ye out to meet him.

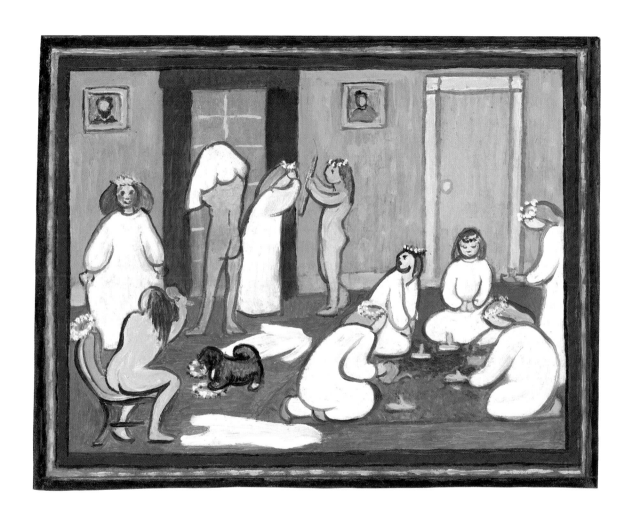

Then all those virgins arose, and trimmed their lamps. And the foolish said unto the wise, Give us of your oil; for our lamps are gone out. But the wise answered, saying, Not so; lest there be not enough for us and you: but go ye rather to them that sell, and buy for yourselves. And while they went to buy, the bridegroom came; and they that were ready went in with him to the marriage: and the door was shut. Afterward came also the other virgins, saying, Lord, Lord, open to us. But he answered and said, Verily I say unto you, I know you not. Watch therefore, for ye know neither the day nor the hour wherein the Son of man cometh.

———————

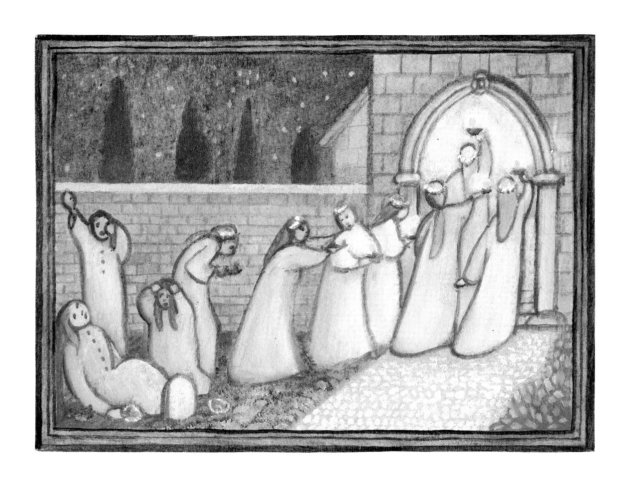